DJ
THE DOG WHO RESCUED *ME*

For information address: Turn The Page Publishing, LLC
www.turnthepagepublishing.com

Library of Congress Control Number: 2013930220
ISBN: 978-1-938501-27-2

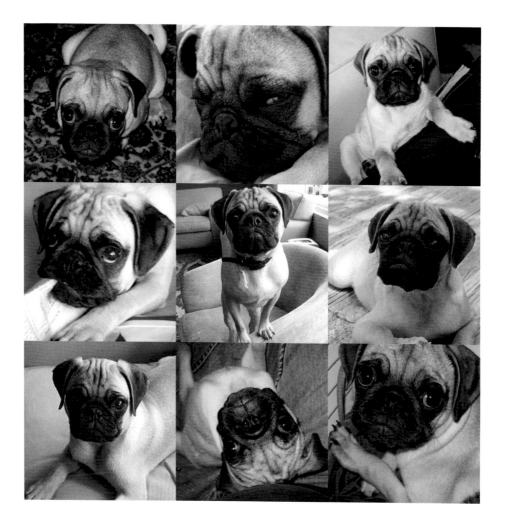

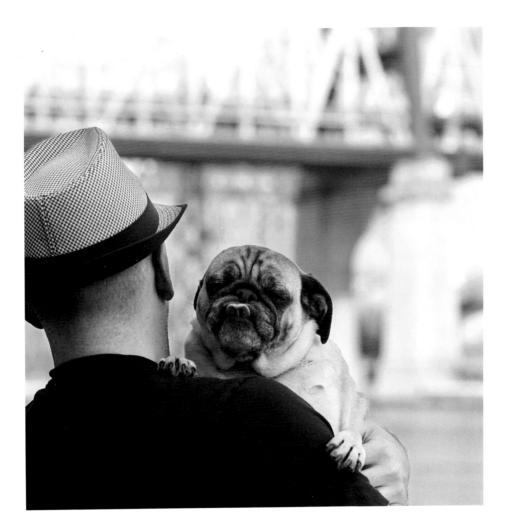

DJ

THE DOG WHO RESCUED *ME*

text by **David Toussaint**

photos by **Piero Ribelli**

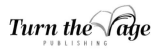

Chapter 1
The Dog Who Rescued Me

The dog who rescued me came into my home on April 28, 2005. On that afternoon, I did exactly what I was told never to do. Depressed, single, and out of work, and just five days after my 41st birthday, I took a stroll to a neighborhood pet store and bought a pug. I hadn't heard all the pet store horror stories about dogs, and I've since learned my lesson. All of that's moot now, because I have DJ, and I wouldn't change that gift for the world. The first time DJ crawled on my shoulder I was his. I'd seen him exactly three times before: when I'd visited the store on the 27, the 26, and 25 of April. Each visit was the highlight of my day. At night, I'd imagine him in his cage, sad that he was alone and terrified the wrong person would take him. I'd wanted a pug since college, where a woman in my building had two. Her dogs were mythical, and every time I saw them they leaped up and kissed me. She was always apologizing for their affectionate behavior, but I couldn't get enough.

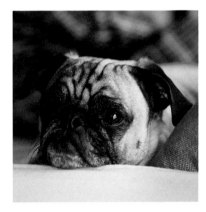

When I made New York my home in 1988, I was determined to get a pug, but the timing was never right. Leap forward 17 years and four apartments later, and I was beginning my post-40 years in bed. I had a running joke that suicide was out of the question as no one would be interested in publishing my obituary. Sure, I'd just had my first book published, by Random House no less, but like the actor in a hit series, after the buzz dies down no one wants you and no one returns your calls—including your agent.

Ironically, the book was a gay couple's wedding guide, and I'd just spent a year of my life telling men in love how to plan their day. I had all the advice in the world, but none for myself. A dog seemed like a smart idea. Actually, it was the only idea. Love was there, puffing up my veins the way cholesterol clogs arteries. I needed to share it.

After I first saw DJ, I checked out shelters, and talked to people who'd purchased dogs from the pet store where I'd seen him.

I also learned I could get a pug from a breeder upstate, but it would take about a year, provided they approved me. When I told the people on the phone I wanted a pug they quizzed me like a terrorist trying to get a dirty bomb. Still, I couldn't make up my mind about where to get a pug until I read a quote saying "the dog you buy is the dog you fall in love with." As soon as I read those words I rushed to the store and signed on the dotted line.

DJ was three-months-old when I brought him to my apartment. I plopped him on the floor and panicked. People spend their lives thinking about raising a child. A dog is different, but if you're a good parent to an adopted animal, you realize that he, too, is going to change your life in ways you can't imagine. DJ's eyes, when he looked at me, branded me with responsibility. My home was his; it was the place where he'd grow up and, hopefully, grow old. It wasn't just about house training and food and finding the right chew toys.

Animals aren't made for our convenience or our whims, and they are not really ours. The care is give and take. Pets are also not accessories to match our furniture or clothes or cars. My dog crawled on my shoulder, this time as property, and told me that I was now his guardian and caretaker and friend.

It was as scary as it was wonderful. I didn't know if I could do it right.

DJ's name is derived from "David Junior," as none of my friends or relatives have children named David, and I am the end of my own line. For the record, however, I don't call him David Junior, and he's listed as "DJ" (no periods in between letters) on all of his documents, because calling him David Junior would just be a little bit eepy-cray.

A couple of weeks after DJ came into my life, a friend of mine asked me if I was still depressed. I answered, "I don't have time to be depressed; I have DJ."

The following, then, is his story, and mine. It's a tale, and a tail, of love. 🐾

DJ's first home was not a crate, but my kitchen. I have nothing against crating, but since two friends with dogs did not crate their pets, and since I grew up with an un-crated dog, I decided to go the old-fashioned route. My kitchen is very small, with two doors that seal it off. It seemed like the perfect home, so I ran out with all the excitement of a new mom and bought DJ his very own indestructible bed. He destroyed it within a week. After that, I switched to comforters. After he destroyed them, I switched to old blankets and towels. After he destroyed them and I could no longer risk stealing new towels from the gym, and after he scratched off half the paint on the kitchen wall to get attention, I decided he was mature enough to sleep with me.

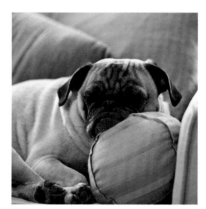

I have nothing against the Dog Whisperer either, though I am sometimes unnerved by those Nazi pet owners who march down the avenue, dog firmly in leash, barking commands and pulling on chains and always somehow reminding me of the Grinch forcing that poor dog down the mountain against his will. If confronted by a passerby the owners always scream out, "They're not human!" I'm sure the dogs are thinking the same thing.

Once you get a dog, people will give you wonderful advice on how to raise him with ease. You'll be told that putting a light near where he sleeps or leaving the radio on for him at night is a great way to lull him to sleep. I highly recommend these stories, if only for the sheer laughter they provide while your dog is turning your home into a frat house after finals.

I bought three "learning manuals"—two on pugs, one on dogs in general. I gained a lot of knowledge, most notably the fact that almost everything you read is a lie. Yes, pugs shed (as the saying goes, "just once—all year long"), but most of the other stuff was absurd. One book said that pugs, don't need much exercise, "maybe an hour or so a week." DJ requires an hour of exercise every hour.

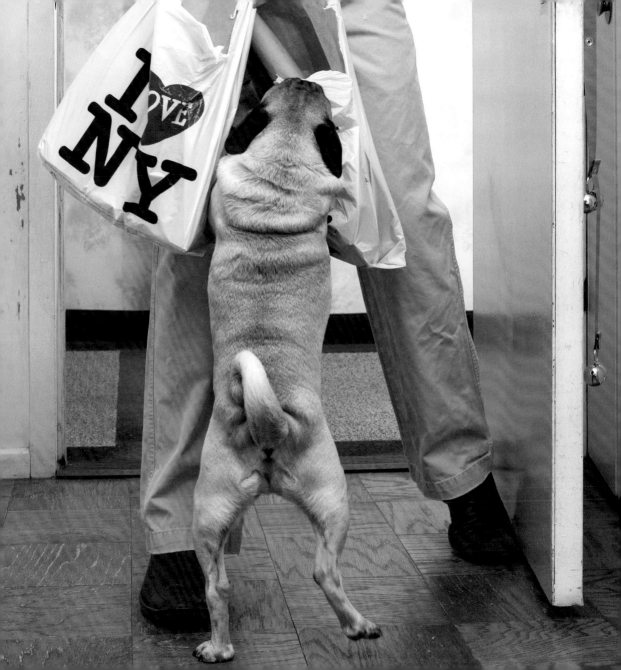

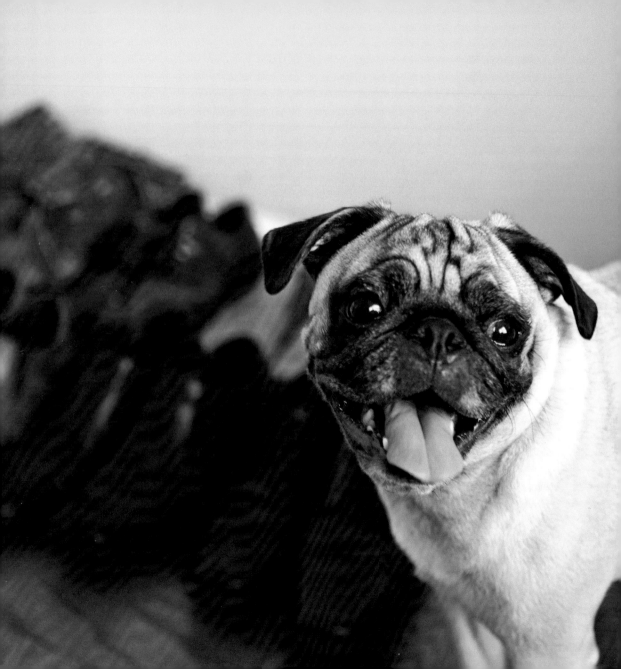

He leaps, spins, flies, twirls, jumps, runs, gallops, and scales walls. And that's after six years. When I first got him, he also chewed everything in the apartment.

With the exception of shoes: DJ has no interest in shoes.

Since DJ moved in, I've replaced two chairs, a couch, a nightstand, even a Sherpa—he chewed through the wire. The desk that I am writing on has bite marks on the knobs. Since it's a family antique, I have decided to consider the marks "character." Talk to anyone and they will tell you about those wonderful spray products you could use to give furniture an unappealing smell that dogs hate. I used them all, as did DJ. I'm sure he just thought they enhanced the flavor of maple and pine. As for shedding, I got smart and replaced all the furniture and comforters with colors that match his fur. I refer to my black clothes as "pug-enhanced."

Like I said before, I work at home, and DJ quickly adjusted to my schedule. He learned early on what each outfit meant (jacket meant I was going out for a while, long looks in the closet meant I was going out for a long while, flip-flops meant his walk). The plastic garbage bag meant I was only going outside the door for a couple of seconds, and the words "send him up" on the phone meant a delivery boy was about to bring food, and DJ could whimper and leap and jump against walls, knowing a new friend was about to knock. Dogs watch your every move. It astounds me how quickly they learn what your actions mean.

Any "suspicious" exits from the apartment were not welcome. One morning I had a job interview about five blocks from home. It was fairly early, around nine, and I put DJ in the kitchen, closed the door, and left. By this time he'd gotten used to that area, and accepted it as "quiet time." Provided I didn't veer off schedule.

The interview lasted about an hour, and when I returned, I opened the door to what I first thought was a robbery, and then realized was a terrorist attack—by DJ. I'd accidentally left the kitchen door ajar, and DJ had destroyed everything in the apartment. Towels had been torn off racks and thrown on the floor, pillows were everywhere, with the stuffing pulled out, all my shirts and jeans and socks (no shoes) were in piles on the floor. In the middle of the mess sat DJ, on his hind legs, staring at me. He didn't bark or whine or whimper, and he didn't approach me. He just stared.

DJ

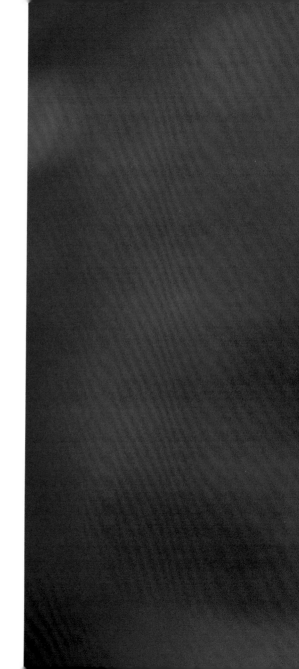

Everyone who's parented a dog knows that look. I felt like Sophie after her choice. When I turned to lock the front door I noticed a pile of shavings about six inches high, and beyond that a scratched-to-bits wall. DJ had tried to claw his way out of the apartment. Had I been gone much longer, he probably would have succeeded.

If you don't have a dog, and don't particularly care for them, you may find yourself baffled as to why anyone would tolerate such behavior. Dogs are exhausting and expensive and they don't give you grandchildren. But if you've ever heard that sound of little feet scratching the floor, that noise that means a creature is searching for you, or felt the fur or hair next to you while you read your favorite book or watch a movie, or heard the sound of a dog lapping up water from the bowl after playtime, then you understand the sacrifice. Dogs make your home come alive. When you walk in the door and turn on the light, their personalities burst from corner to corner and through the roof. It's not something you think about; it's something you feel. 🐾

DJ

One of the reasons many of us choose to live in New York is the vibrancy. As if you're in the heart of the universe, every race, ethnicity, neighborhood, and noise blares at you simultaneously. One of the sad things about living in New York for a long period of time is that you forget what surrounds you. Someone once told me that as soon as you stop looking up at the Empire State Building, the magic is gone. Although I vowed never to become that person, my dog made me realize I'd metamorphosized long ago.

Once I started walking DJ, a new world opened up, for both of us. The puppy, who was about 10 pounds at the time, jumped at every horn, siren, door slam, argument, and anything that wasn't "natural." I'd completely forgotten how loud door gates are when the shopkeepers lock them up. DJ also cried when he saw pigeons, and he took to homeless men without judgment. He discovered pre-war stoops and the multitude of nature's wonders in the park—grass, trees, squirrels. Thanks to DJ, some of my blind-sightedness has been restored.

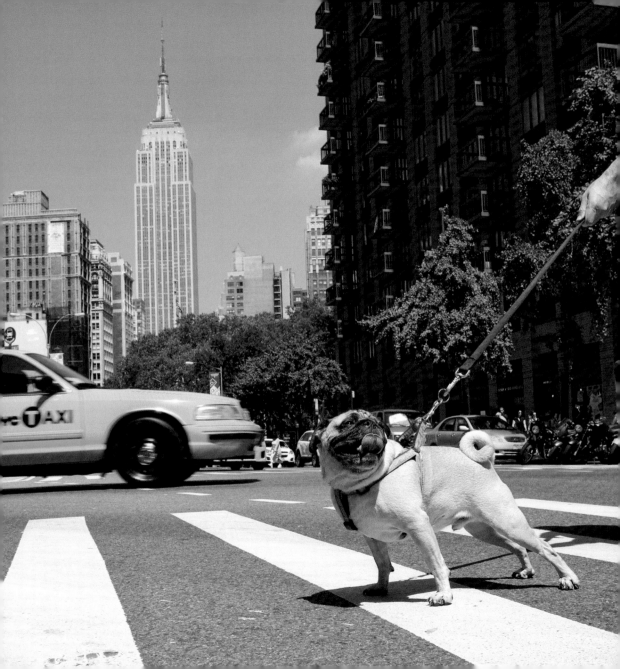

DJ

Soon, DJ became a "New Yorker," and I still laugh at my 20-pound, foot-high dog trotting along six-lane avenues amid speeding cabs and buses and drunken partiers. I find it especially amusing when I have friends or relatives too afraid to walk around this "dangerous" city. DJ still looks up when he hears someone blabbing on a cell phone. Ambulances and fire trucks don't register, but a misplaced, loud voice turns his head and alerts him to a noise that interrupts the city's natural flow.

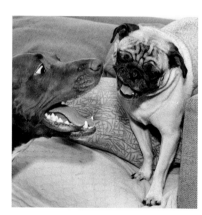

New York is a small town, and when I walk out of my building I say hi to the dry cleaner, the florist, the barber, the locksmith guy, and the deli owners. DJ loves people—all of my doormen are "forced" to give him love when he comes and goes. (The night doorman prepares for DJ's arrival by bending down from the knees ahead of time—he has a bad back.) DJ's gotten to know all of these characters, as well as a subset of New Yorkers I never paid much attention to—other dog owners.

DJ matured in the warm months of 2005, and summer nights were spent chatting with dozens of people in the neighborhood I'd never met. I'd passed these guys hundreds of times in the years I've lived here, saw them in the grocery store, waited on the subway platform with them, spotted them in the gym. But I'd never spoken to them. Dogs are mediators and diplomats. Underneath, it's not really about our canines. It starts that way— What breed is he? How old? What food does he like?— Was he difficult to house train?—then turns into more serious conversations. It's about us. We all need to share stories and connect. Dogs enable us to engage with people we'd otherwise probably never meet, yet who often spend their lives a short distance away. I'm now on a first-name basis with about 50 *dogs* on the few blocks around my home. Once I remember all the owner's names it'll really be progress.

Still, it's a start. 🐾

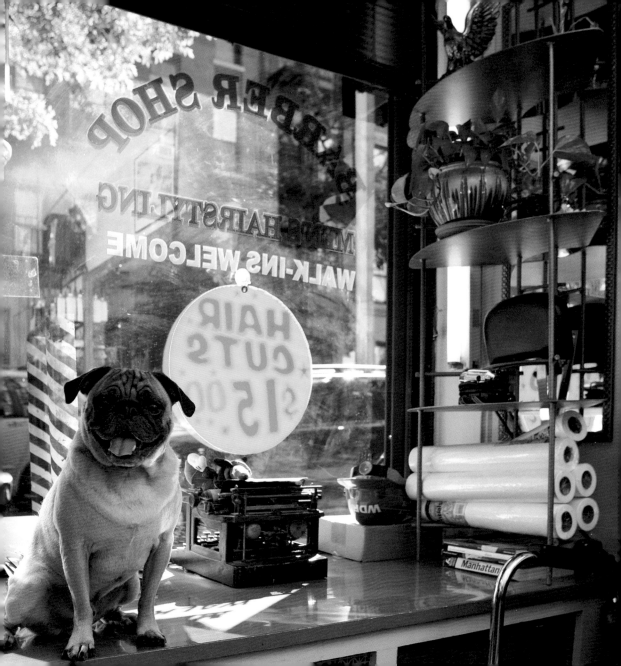

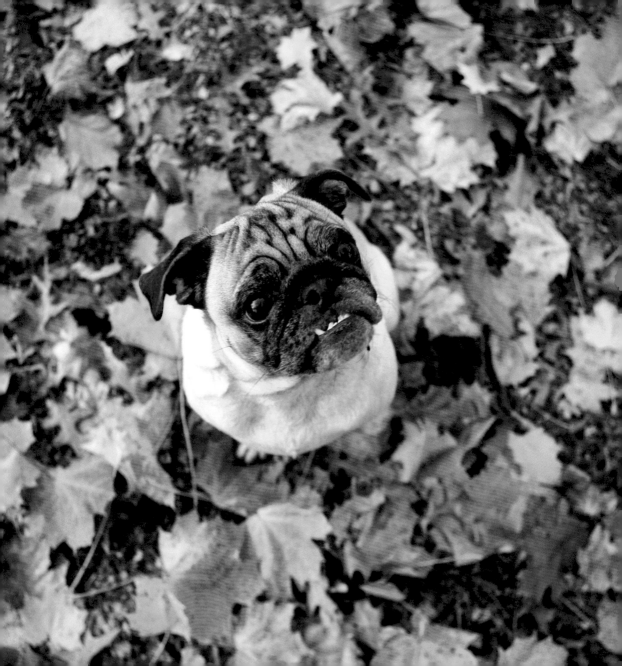

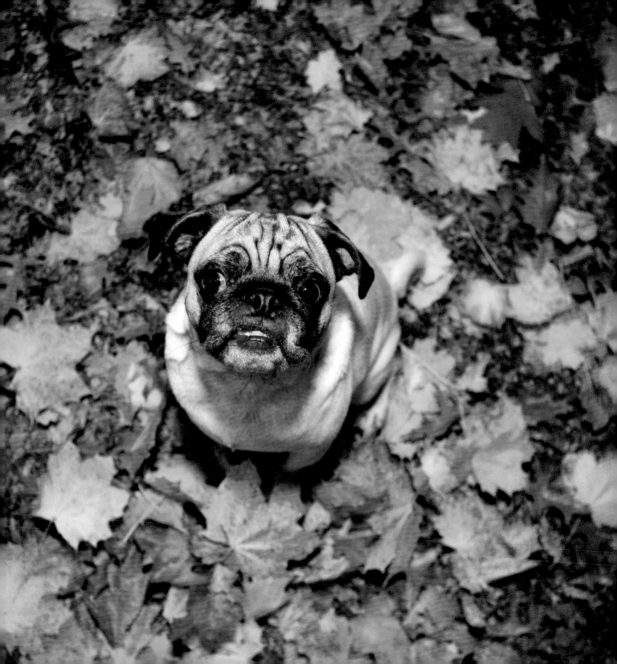

Chapter 4
Hyde and Prejudice

Pugs are not considered conventional-looking dogs, a statement that has always seemed a bit ironic, considering they are animals, not soap stars. People compare them to aliens (or, as in the case of *Men in Black*, cast them as one), gremlins, Yoda, and Edward G. Robinson. I've heard everything from "He's so ugly he's cute," to "That's a face not even a mother could love," to "He must make a great pet 'cause, damn, is he hideous." Those people are perfectly entitled to their opinions, just as I'm entitled to comment on their own repulsive features and bad fashion sense.

DJ has an under-bite, which is common to the species. On more than a few occasions

I've been told that my dog needs braces. There's an older woman in my building who makes a snarky remark about DJ's teeth every time we share the elevator. When I walk my neighbor's more-conventional Wheaton Terrier, the woman coos and treats the Terrier like the adorable and "correct" dog that DJ is not. If, as happens sometimes, both dogs are together, she smothers the Wheaton with attention while DJ looks on, innocently waiting for his turn. If it reminds me of the racists from my childhood, perhaps it's because she once whispered in my ear that if I didn't fix DJ's teeth, he'd resemble a Harlem rapper. I've never quite made the physical connection between DJ and any rapper (except maybe his name), but the sentiment is familiar. One time when I saw the Lady in the Elevator, she looked at DJ and reminded me that it was cruel to keep a dog in the city, and that her daughter's Lab was infinitely happier with a yard and trees. "It's okay," she then reassured me. "I'm sure he doesn't know any better."

I said nothing, just stared. I must have trained her well for when I see her nowadays, and I'm alone, she asks me, "How is your 'friend'?" in the same way people twenty years ago used to inquire about my boyfriends.

Two steps forward, one paw back.

In the high-rise building next door to my apartment there used to live a woman in her mid-20's who had a Golden Retriever named Bella. Her dog and DJ were almost the same age, and in many ways, the two puppies grew up together. They played on the street as she and I traded Wee-Wee Pad secrets and debated harness versus leash. After a couple of years passed, she informed me that she and her husband were leaving New York for the Connecticut suburbs. She was pregnant and there was no longer enough room. Life, she told me, was good, her husband had a fabulous promotion, and little Bella (who'd been a birthday gift) would do much better with grass and trees.

I hugged her and congratulated her on all her good news and was about to pet Bella, when she looked down at DJ in disdain. "That's the exact same sweater he wore last season," she sighed before grabbing Bella and running off without any acknowledgement. I looked down at my dog in his adorable fleece sweater that didn't itch and that I'd picked out from a store that specializes in pug-wear, and that he never fusses about or tries to yank off, and that made me cry when I pulled it out of the drawer for his second winter.

I love that sweater. I love how it fits DJ— how he lifts his paws to let me slip it on him—with little leg/sleeves that make him look like he's dressed for his first day at school. I love taking it out each year, cleaning it, and knowing it's the change of seasons. And I love that it keeps him warm.

For a moment, I was afraid my dog wasn't up to snuff. I even worried others would frown upon my unkempt canine. When I was a child, I was taught never to care about what others thought of me and to ignore the pretentions of ignorant people. Now that I've grown up, I've included in that list another group of people who value style over substance: pet snobs. 🐾

Chapter 5
In the Belly of the Beast

There's one term people use to describe DJ that I never let slide: "Fat." While I don't think I've (quite) grown to resemble my dog, I have instilled some of my own diet and fitness habits into his regimen.

I was an overweight child who didn't get fit until my mid-twenties. I've been exercising and eating well for two decades, and I had no intention of letting DJ get out of shape. DJ has a strict diet; he is not allowed table scraps, and I exercise him almost every day, no matter the weather. I discovered early on that he's nuts about baby carrots, and would just as soon eat one of those for a treat than a store-bought biscuit.

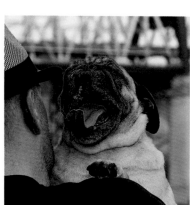

It's not about vanity: I want to live a long and healthy life, and, as DJ's guardian, I'm doing my best to make sure he does too. Pugs are among the dog breeds that keep eating as long as you feed them, and DJ's mastered the "Please, Sir, Can I have some more?" look so well he could stare a homeless person out of his last piece of bread.

Ironically, my dog has helped me confront my own insecurities. All too often, I get up in the morning and look in the mirror, and my eyes go straight to the waistline. I forget to look at my smile and my eyes, and I forget to look inside. DJ's not worried about his belly or his pecs; he's not regretting yesterday or anxious about tomorrow. He's living in the now. It rubs off. About six months after I adopted DJ, I went to Boston and left DJ for the first time. It was highly traumatic—for me. A friend looked at me and said, "Do you ever smile?" Her comment saddened me. I'd been hurt so many times, that I'd grown afraid of my own happiness; fearful that someone would see my smile and not reciprocate. When she asked about DJ I broke out in an ear-to-ear grin. Since that day I'm learning to keep that feeling alive. The world inspires love if we allow it inside. It took an unconventional-looking, "fat" Edward G. Robinson lookalike alien with an under-bite to make me understand the obvious.

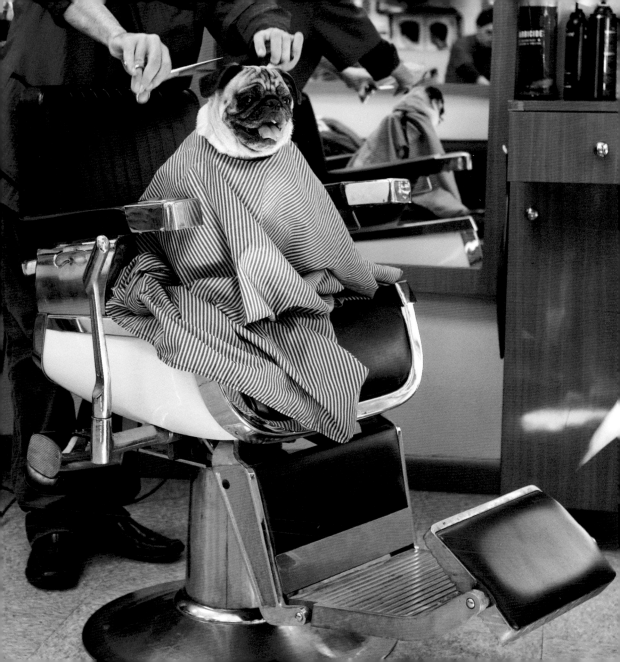

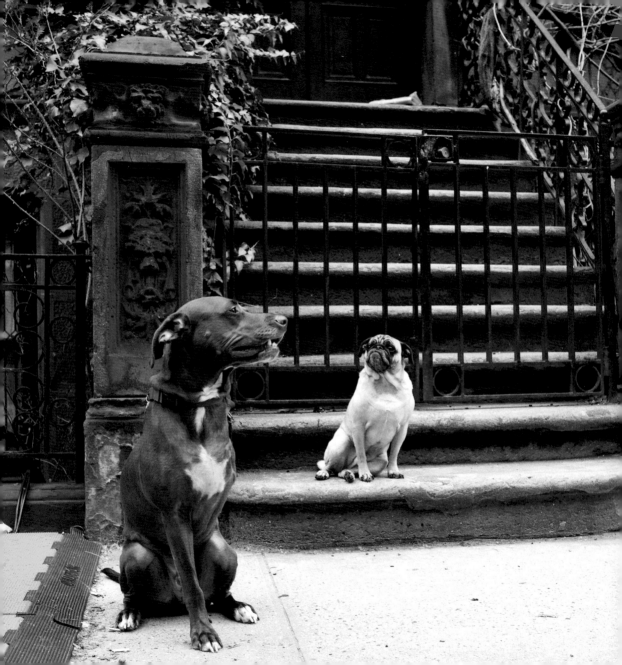

There's a dog run in our neighborhood where I've been taking DJ since he was four-months-old. To this day if I say "park" he twirls and jumps and scratches the door, then races past everything and everyone until we arrive. The first time I brought DJ there I set him free to roam, sat down, and panicked.

All the other dogs ignored him; some even snapped. My mind raced back to elementary school, when I'd sit by myself at lunch, desperately hoping someone would talk to me. Some of those students, if they did drop by, also snapped. I stared at DJ, alone, and then looked at the adults, certain they were whispering about the "loser pug" with his "loser dad." DJ was as much of a misfit as I was, and somehow I was to blame.

Things soon changed. DJ turned into a fetch pro, coveting balls like the Olympic torch. He made the grade and could catch a ball clear across the park. Then he'd run past all the other dogs, head held high, like a football player determined to make a touchdown… at my feet. Pug owners approach me all the time to ask how I taught him that skill. All I can say is that he didn't inherit it from me. Then I sit back with my book, watch the game, and think, "That's my boy." ❧

Chapter 6
Dog Days and Afternoons

Every dog owner can tell you about the unconditional love we receive from canines. Part of the reason we love them is because they don't judge us on our looks or our money or our status. What I didn't fully realize until DJ came into my home is how much we serve as their lifelines. We talk about how many words our dogs grasp (DJ has a much better understanding of the English language than half the guys I've dated), and there's a reason for that. Our dogs study us.

DJ's day is almost entirely dependent on my schedule. He gets up about 20 minutes after I do, around 9:00 a.m. Since I go straight to the computer, he rubs his face against my leg so I know he's awake, then sits on my lap until I'm finished answering emails. When I take him out for his walk, he can hear which elevator of the two is stopping on our floor, so he knows which door to stand in front of. If it's a sunny day, he automatically sits on the stoop before his jaunt. (He doesn't care for rain.)

After our walk and breakfast, DJ promptly jumps up onto the couch, ears up, and waits for me. This is the time I read the paper, and he loves the routine as much as I do. As I peruse, he chews a toy until he falls asleep.

Next is what I call Bootcamp Fetch. I put down the paper, say "Fetch," and he's all spins and barks and racing-feet prep. We rapid-fire (he gets one ball, I throw another) for about 20 minutes, or until he passes out. DJ naps and I work. If he sees me put my iPod on, he sleeps on the couch, as he's learned that means I need to be alone—I use it sometimes when I'm writing. When I say "Shower," he knows I'm gonna be in the bathroom for a while, and he moves to the bed. When the gym bag appears, he knows I'm leaving, and he goes to perch on the couch, facing the door. When I come home, he's in the same spot. After our evening walk and his dinner, it's Bootcamp Fetch again, unless it's warm enough to take him to the park. DJ has a biscuit while I eat dinner, then he sits under the table.

If I have work to finish after dinner, he sits on my lap patiently. After his last walk of the night, and his carrot, he waits on the floor for me to get ready for bed. He looks at me ponder snacks in the fridge, brush my teeth, make last-minute emails, and clean up. When I say "time to go to bed" he runs into the next room and props himself on the pillows, sitting on his butt. Once I'm settled in, he goes under the covers.

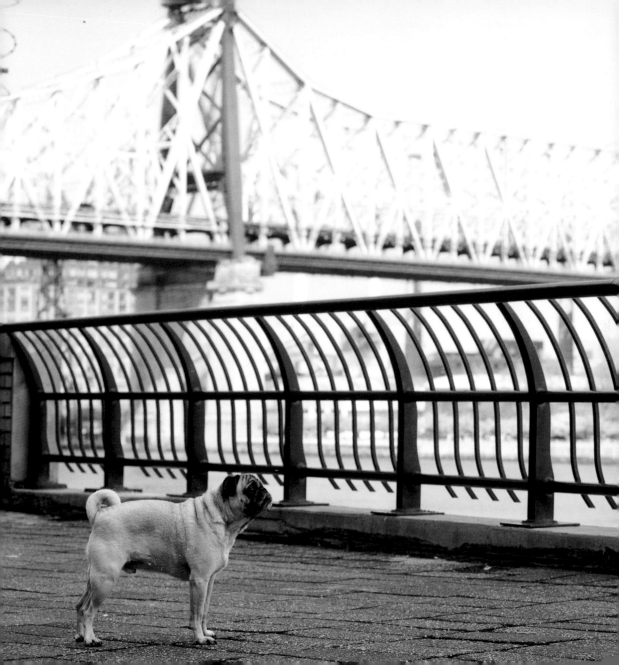

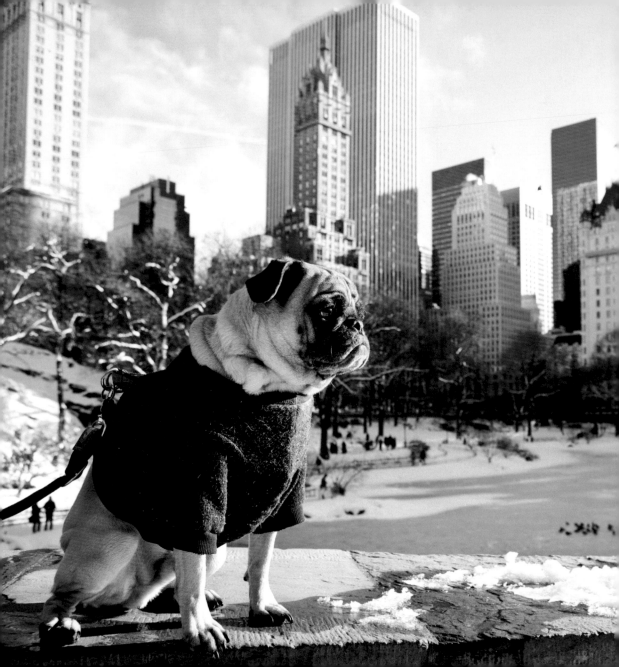

There are variations on this routine, and they all have an effect on DJ. He won't touch his breakfast if I leave early in the morning; it waits until I come home. If the yellow bottle comes out of the cupboard—his shampoo—it's time for a bath and for him to hide. And if I talk into that annoying black thing (my Blackberry), it means surrendering to the fact that I'm going to be ignoring him, or take matters into his own paws and run to the other rooms for socks, towels, shirts, anything he can drag out to get my attention—except shoes.

Olive oil from the kitchen means "Italian Night"—he gets a drop every other evening—and more circles and woofs. And if that Ben & Jerry's lid is opened, his bionic ear sends him flying into the kitchen in the hope some will spill on the floor. I don't have to be a scientist to realize that DJ knows these routines, and words, from habit.

The only being who spends more time in this apartment than me is DJ. His world is set in this place, and my duty is to make it a wonderful environment. Although I often take him when I travel now, his life is here, on the 10th floor of an East 86th Street apartment. If I'm a good adoptive parent, the block does indeed revolve around him. ❧

Chapter 7
Paws and All

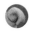

Not long after I adopted DJ, I developed what I refer to as my "period of sickness." For a couple of years I was susceptible to mild colds and flu, but every doctor and every test I took assured me I was okay. One specialist referred to it as "a phase." There was a period of time when it got so bad that every day around one o'clock I'd stop working and go to bed.

DJ was on it. No sooner would I jump into bed, face down, than DJ would soar into the room, leap onto the bed, and start licking my face and arms. After about five minutes, he'd plop on top of my head and go to sleep. Although I'd have to turn sideways to breathe, it was the most relaxing therapy I could ask for. When I woke, DJ was still there.

My symptoms eventually dissipated, but the "therapy" did not. To this day, if I decide to take an afternoon siesta, DJ repeats the ritual. I used to be a travel writer, and have experienced massages from Five Star hotels all over the world. Nothing compares to the relaxation of a dog sleeping on your head. It's a marketable skill.

I mentioned at the beginning of this story that I was depressed at the time that DJ came into my life. During much of the first two years of his life, that depression lingered. There were times when getting out of bed was a struggle. Work was scarce, dating was non-existent, and I would often look at my life as a ticking clock of failure. Dogs don't cure depression, and it would be unwise to try to use them as a substitute for friends and, perhaps worse, socializing.

What DJ enabled me to do was to take joy in little things. I'm not sure I ever realized how much fun it is to sit on a stoop and people-watch until I brought my dog with me. Their pleasure at life's gifts is a reminder to relish each day. I don't think DJ is concerned about whether or not he's going to move into a bigger apartment and get a fabulous new book deal, but I'm quite certain he will jump for infinite joy if a friend drops by to say hello. If a breeze sifts through the window, he lifts up his nose and takes it in, then stretches out and bathes in the heaven of the day.

The longer I had DJ, the more I employed his strategy. On bad days I wouldn't try to do too much, and instead was grateful for the little things. Sometimes you need a kick in the pants, and a dog gives you that. I have to walk DJ three times a day, rain or shine or cold or heat. I have to play with him, keep him healthy, bathe him, take him to the vet.

DJ

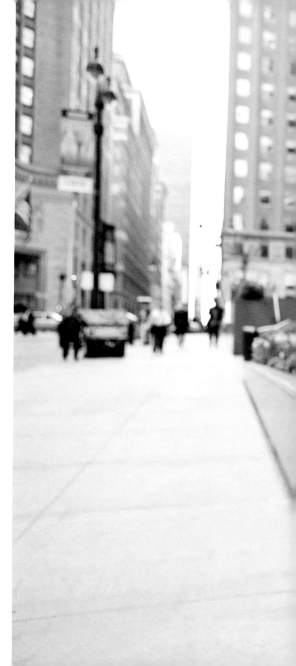

Sometimes I'd rather let him fend for himself, and, of course, that's not possible. I hope that living with DJ has made me a little less self-centered. This is a dog who forced me to get up on those mornings when sleeping on the floor seemed easier than making it all the way up to the bed.

Most of us don't think we can change the world, and many of us feel as if our efforts are pointless. There's an exercise I've discovered that proves this theory to be false. Love your dog; nurture him, play with him, know that he's like a sponge and that any affection you give him will be absorbed. Then take him outside. People will smile at him, children will ask if they can pet him, adults will get down on their knees. Your dog will return their attention with love. You will notice how a seemingly small act of generosity is contagious, and a little bit of cheer has been spread.

Someone once asked me if I would be able to spot DJ in a crowd of a thousand pugs. I thought about how I'd do it—I know about the black mark under his tongue, the cowlick on his right ear, the black at the tip of his tail, and so many other things. But I don't worry about that anymore. DJ, I'm quite certain, would spot me. 🐾

Chapter 8
The Big Apple Chew Toy

Dogs, I have often heard, are guy magnets. I'm fairly certain this rumor comes from the same people who tell you that all those furniture repellents are effective. I've never had one man approach my dog and then start flirting with me. I've had about a million women stop me, families of tourists, those nuts who want to baptize my pooch—I remind them that DJ, like his dad, is possessed by Satan—but no men. Not even to tell me that DJ shouldn't jump up on people's legs to greet them—not that I'd ever stoop to such a blatantly flirtatious tactic.

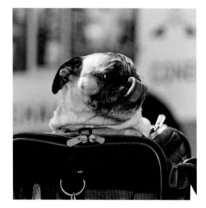

The closest I've gotten to cute men approaching my dog is when their really cute girlfriends insist on playing with DJ, The women turn and say they want to get a pug. The boyfriends inevitably give me that "Yeah, I can't pretend to think a little dog is adorable because I'm a guy" macho shrug, and back off to the side. I get the same reaction when I tell straight men at the gym that it looks as if their workouts are paying off nicely.

A few years after DJ arrived I dated a guy in Miami. He loved dogs, and suggested I bring DJ along when I visited. I was terrified; I'd never been one to take DJ on the subway—what happens if he doesn't get a seat?—and I didn't like putting him in taxis or cars. I got over the car fear, and DJ loves air flying around his face.

But an airplane was different. How do I explain turbulence to my dog? What happens if those yellow oxygen things come down? Does DJ get his own, or am I supposed to put mine over his nose? They don't give you that information in the safety books, because believe me, I checked.

The first time I went to Miami I left DJ with a friend. Every day I got a panicked report on DJ's behavior. First, he threw up all over the apartment. Next, he had diarrhea. After that he went on a hunger strike. I got a call saying I needed to come home—now—as DJ hadn't eaten in days. DJ survived, as did I (barely), but I'd decided I'd rather take him with me in the future.

DJ didn't care for the Sherpa and going through Security. He did enjoy leaping out of my arms and running through the terminal. Once on the plane, he snoozed. He turned to face north when the plane took off, and he turned south when we were landing. Other than that, not a peep. I could have used the sedative. He soon became a frequent-flier, as I hit Miami six times during the year I was in that relationship.

DJ loved my boyfriend, so much so that he insisted on sleeping next to him—in between us. He loved his black couches, so much so that he insisted on jumping on them and shedding everywhere. He loved being around both of us so much that "private time" was met

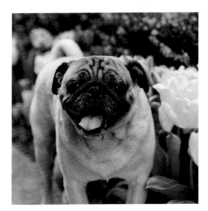

with cries outside the door, then scratches on the wall. And he loved kissing my boyfriend almost as much as I did.

My dog had nothing to do with our breakup, but I now tell men that DJ and I are like Will and Grace; you don't get one without the other. I take complete blame for behavior that other people find inappropriate, but you have to remember that, as a single man when I adopted DJ, these were issues I'd never dealt with. Slowly I learned how to break him of habits he's used to at home, and I'm certain that I can do it again. A word of advice: If your dog won't allow you and your partner alone time, try putting a Bully Stick outside the door before you close it. Yes, it felt a bit like giving alcohol to a baby to quiet his tantrum, but it did the trick.

There are many people who think owning a dog in Manhattan is cruel, and I understand that line of reasoning. We don't have big yards for them to play in, and even nice apartments are small. My boyfriend in Miami lived in a gated neighborhood, with a large home and a huge backyard. I assumed DJ would think it was paradise.

But I came to realize how good DJ's quality of life is in Manhattan. In Florida, he could rarely play in the backyard, as Miami can be extremely hot and pugs overheat.

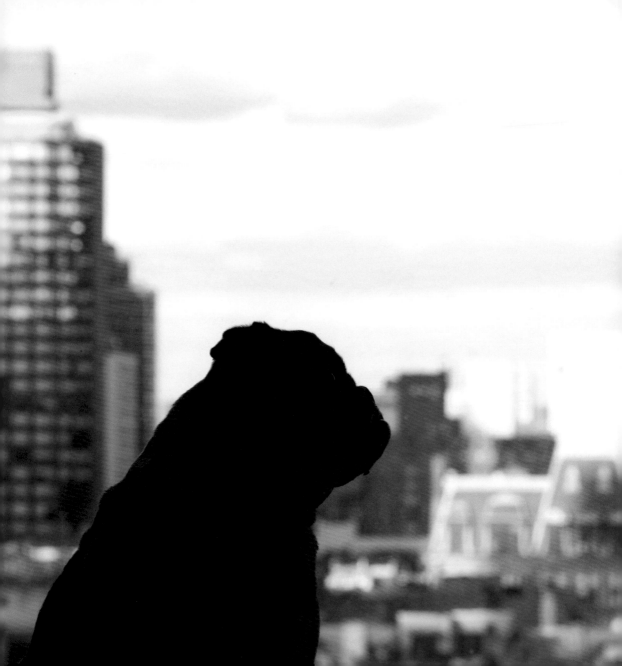

When we went on our walks, we rarely saw dogs, and we never saw florists or barbers or bums. We also rarely saw neighbors, as no one in the area ever seemed to walk, unless it was from the front door to the SUV. It was a serene, beautiful neighborhood, yet DJ would perk up as soon as we got back to the Melting Pot called home.

A veterinarian once told me that DJ should be around as many people and other dogs as possible. Here in Manhattan, that starts in the hallway—there are two other dogs on our floor, and there have always been children. He knows half the people in the building, and, on the street, DJ has more fans than Cher. There have been many days where I've taken DJ out for a quick walk around the block only to return an hour later because we stopped and chatted with everyone.

I would never say that a particular environment is best for your dog, but I do think that you learn to make the best with what you have to offer. Dogs, like children, adapt to different surroundings, provided the one thing that never changes is your unconditional love. And if you do meet a handsome stranger in the process, then that's the best dog-gone karma in the world. ❧

Chapter 9
Hind Sight

Adopting DJ made me realize that finding a great vet is right up there with finding a great general practitioner. The first veterinarian was recommended by the pet store, and on our initial visit I asked the doctor if pugs can swim. I'd heard rumors that their flat faces make it impossible. Since I have a friend in the Hamptons with a pool, I needed to know if I should be worried. The veterinarian evaded the question for so long that I realized he didn't have a clue. When I insisted he answer, he said, "Drop him in the pool and see what happens." I dropped the vet. (For the record, DJ knows how to swim; he doesn't care for the sport, but he dog paddles like the best of 'em.) DJ's second vet misdiagnosed him with elbow dysplasia, and I spent several terrified months not knowing if DJ would need major surgery, not knowing if he was in terrible pain, and not knowing if he'd have a very long life. I later learned that DJ had simply twisted his ankle. The vet that misdiagnosed him left New York, and left me with a lot of bills.

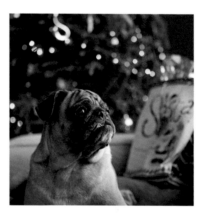

The third vet yelled at me when DJ wouldn't let her hold his head to examine his teeth; pugs are head-shy because of their unprotected features. She then insisted on selling me hundreds of dollars worth of dog products and sedating DJ. I insisted that she bite me. Neither one of us gave in.

My fourth and current vet is a lifesaver. When DJ broke out in a nasty rash of warts, the doctor told me they were not in a dangerous place, and to let them run their course. When DJ's teeth needed to be examined, my vet never sedated DJ; he brought in an extra hand who knew how to correctly hold a pug's face. He also talked me out of a lot of unnecessary vaccines and has never tried to sell me so much as dog shampoo.

DJ's doctor became a hero during the Christmas season of 2008. I decided to celebrate the holidays with a small party. I bought a tree, I decorated the apartment with lights and candles, and I bombarded the sound system with Christmas music.

The guests were mostly other apartment residents, along with a few close friends. DJ, I knew, would be the star, regardless of whether or not he sat on the top of the tree.

That morning DJ and I were playing Bootcamp Fetch, and I noticed he had difficultly spotting the ball when it was directly in front of him. I didn't think much of it until that evening, when, as I was setting the table, DJ bumped into the bedroom wall. I made a point to call the vet the next day.

The next morning, Monday, I called the vet who let me bring in DJ immediately. Christmas was on a Friday, and they would be closed on Christmas Eve. I knew right away by my vet's reaction that something was seriously wrong. DJ had lost almost all of the sight in his right eye. The doctor had no idea if he could save what was left, and said it was quite possible he'd go blind in both eyes.

Since DJ had never been attacked by another dog, the vet's guess was Lyme disease. Problem was, every optometrist in the New York area was on vacation, and there would be no way to have conclusive answers until the following Monday. DJ was taken from me, stuck on an IV, and I was told to go home.

Just like that.

The next day, the vet called me half a dozen times with bad news. He'd used every connection he had, but no one in New York would see DJ during the holiday week. In the meantime, DJ was losing more of his sight and the vet put him on several antibiotics and steroids. He mentioned one optometrist upstate that I could try, but he'd spoken to that doctor, who had said he didn't think it was worth it. Apparently, there was emergency surgery that might stop the damage from spreading. It would cost several thousand dollars and the nearest qualified surgeon lived in Chicago.

I wasn't allowed to see DJ that night, as I was told the excitement wouldn't be good for him. Ditto the next night. I received updates practically every hour from my vet, none of them good. On Thursday morning, Christmas Eve, I got a call from the vet's office saying DJ could come home. I walked into the waiting room, sat down quietly, and within minutes I heard DJ whimpering uncontrollably. He didn't see me; he smelled me.

They brought him out, still in his Sherpa and harness, like he'd just come back from a routine check-up. I picked him up, my adopted child, and started crying too. We were a mess of tears and whimpers and slobber and love.

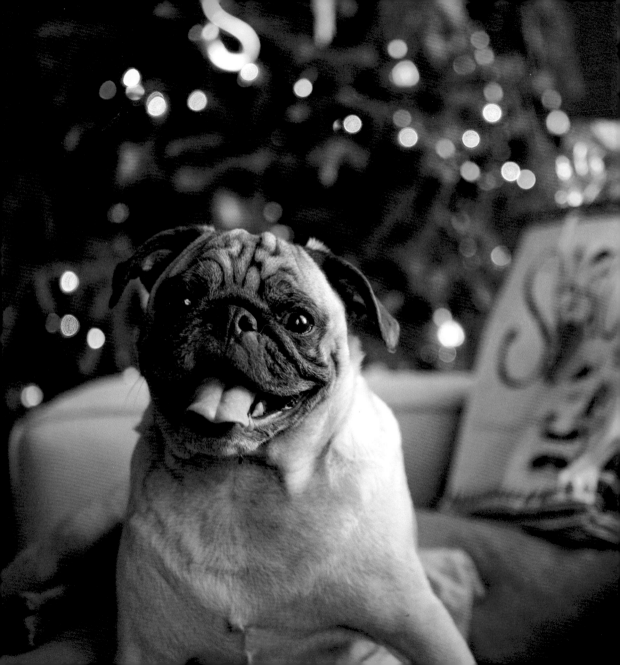

DJ's eyes had stopped deteriorating. He suffered from retinal detachment, and for the time being anyway, it had subsided. My vet said he'd know more on Monday when the results came in. I took DJ home, turned on the tree lights, and climbed into bed. DJ plopped on my lap, stared at me for a bit, then slept. Neither one of us moved for hours.

In recollection, I couldn't have asked for a more perfect Christmas. I spent two days at home canceling what little plans I had. I didn't want to leave DJ, and I didn't need to party or sing carols or eat candy or open presents. Your home, and who or what makes it meaningful, is a gift, whether it's December the 25th or any other time of year.

DJ's sight has remained the same. More importantly, he's still here, full of life. A neighbor of mine who's written dog books reminded me that "dogs see with their noses," and all too often we see them as human, spending thousands of dollars on operations that put them at risk and are more a reflection of our human instincts than what is best for the animal. When DJ and I play fetch now, he cocks his left eye before I throw the ball. It's a trait that no one else would notice. In my eyes, it makes him even more beautiful. 🐾

Chapter 10
My Life as a Dog Lover

As I write this last chapter there is no million dollar book deal in the works, no beach house, and no fiancé working out wedding plans. My day-to-day life involves freelance writing, taking care of myself, eating and sleeping; the usual stuff. I'm surviving like everyone else. I have a few close, wonderful friends and I cherish the time I spend with them. The difference between now and six years ago is that I don't crave what I don't have; I rejoice in the now. My own maturity played a huge part in that gift, and is one of the advantages of getting older. DJ, too, was instrumental in my growth.

My dog is still with me, thank goodness, sleeping on the couch. When I edit these words at a later point, perhaps he'll be on my lap or stretched out on the kitchen tiles. While you're reading this chapter, DJ might be twirling and barking because the delivery guy is at the door, or the two of us could be on a long walk, chatting with the barber or moseying up to another pooch.

If it's a sunny day we may be in the park or heading home, DJ wrapped over my shoulder, his little legs around my waist because he's pooped out. I'm not sure who enjoys this ritual more, him or me. There's a chance that it'll be a cold winter afternoon, and I'll be walking DJ in his sweater or snuggling in front of the TV.

Routines change with time; love is a constant. I wouldn't change my life for anyone else's, and I wouldn't change my time with DJ for anything in the world.

Every year around my birthday Mom calls and says, "What do you need?" For the past six years my answer has been the same: "Nothing; I have DJ." In some respects it's an incomplete answer, but it's filled with truth. DJ brings me more joy than I ever thought possible, and his presence cannot be measured against a material object. I'm a firm believer that as mortal beings, sadness in life is guaranteed; happiness is not. When we receive the gift of love in any form, we need to embrace every moment.

I don't suffer from depression anymore, and if asked why, I'd probably still say that I don't have time. I know that DJ will not be in this house, his house, forever, and for that matter, neither will I. As he's gotten older, his playing is a bit slower, and his metabolism has also slowed, giving him a stockier (not fat!) appearance. His beard is gray—ironically, so is mine. I keep a comforter next to the couch and another one next to the bed so he doesn't have to jump up. He no longer destroys them.

When I first decided to write this book, it seemed like a wonderful idea except for one detail; it means nothing to DJ. I can't explain to him why I need to tell the world his story any more than I can

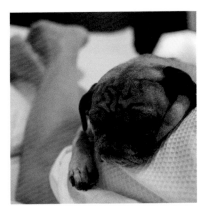

explain to him how elevator doors magically open on different floors. We all share that puzzle with our animals, that magic, and they impart their own secrets. Part of the bittersweet wonder of having a dog is the shared mystery that bonds us and at the same time keeps us at a distance.

Today, DJ wears the same sweater that Bella's mom didn't approve of. As long as it holds out I'm not purchasing another one. A friend of mine knitted him a beautiful wool sweater for Christmas, with adorable, gold buttons on the side. DJ hates it. If I force him to wear it, he tries to pull it off by rubbing back and forth and against the couch. It's tucked away in a bottom drawer among a few other gifts that have never been used. I suppose I could put it on DJ for show every now and then, or if a snooty new neighbor moves into the hood. But I doubt it: the world outside, and the Lady in the Elevator, will have to adjust.

Not long after the dog who rescued me came into my life, he developed a fondness for sitting up next to me, on his butt, then leaning into my side in such a fashion that, were I to move, he'd fall over. Thing is, I never will. DJ knows this and there's no need for words neither one of us can share.

Like all love, it exists in the moment and is understood. 🐾

**"Happiness is a gift and the trick is not to expect it,
but delight in it when it comes."**

Charles Dickens

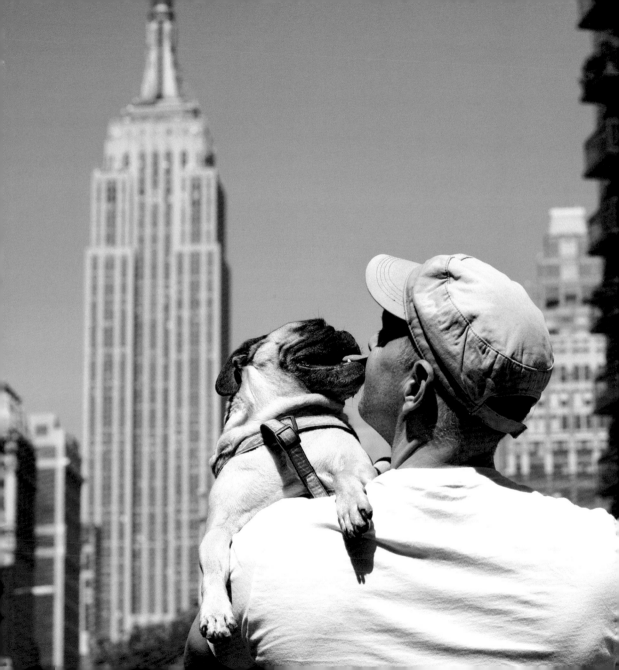

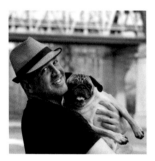

David Toussaint is the author of "The Gay Couple's Guide to Wedding Planning" (RSVP Publishers, 2012), "Toussaint!" (Stay Thirsty Media, 2009). and "Gay and Lesbian Weddings: Planning the Perfect Same Sex Ceremony" (Random House, 2004).

A former writer and editor for Conde Nast Publications, Toussaint is also a professional playwright and actor. He is currently the Senior Editor for GuySpy.com.

Toussaint resides in Manhattan ... with his dog.

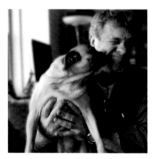

Ranging from travel, portraiture and photojournalism, Piero Ribelli's photographs have appeared in publications around the world.

His previous books include "50 Main Street, The Face of America" (Cameron & Co., 2012), "Zoo York, An Animal Lover's View of Manhattan" (CHP, 2002), and "Jah Pickney, Children of Jamaica" (IRP, 1996), Exhibitions of his work have been staged in Italy, Jamaica and New York, including an exhibit at the United Nations sponsored by UNICEF.

Piero lives in New York City with his wife, Rose, and their twin boys, Hendrix and Morrison.

THANK-YOUS

This book never could have come to pass without the work of the wonderful photographer Piero Ribelli, who I am proud to also call a friend. His patience with DJ, and me, is astounding, and his work speaks for itself. I need to thank Roseann Lentin at Turn The Page Publishing for picking up this idea and taking care of it the way we should all take care of our animals—with love and understanding. A very special thanks to Lisa Calvarese, who I've known for almost 40 years, and who emailed me one day to tell me I needed to do a book about DJ. I'd never entertained the idea until she suggested it. Lisa, we did it! I need to thank Armand Scala, DJ's "other" father, who's loved him all these years in a way that can't be quantified. Also, all of my friends and family who've been forced to hear endless stories and look at endless photos of my "child." Finally, I want to thank the little guy who, no matter where he is right now, is here, in my heart, where he shall remain. I always thought the phrase "I love you more every day" was kind of corny until I met my dog. DJ, aka Little Man, aka The Deej, aka The Monster, aka Angel Face, I smush your face and I promise, as soon as I finish writing these thank-yous, we can snuggle!

ACKNOWLEDGEMENTS

A few people and places need to be singled out for their help:
Fabrizio La Rocca, Leila Matsuura, Rose Austin-Ribelli.
For the use of their businesses:
David's Barbershop, 233 East 84th Street, New York, NY 10028, www.davidsbarbershop.com
Ivy Terrace Bed and Breakfast, 230 East 58 Street, New York, NY 10022, www.ivyterrace.com

A NOTE FROM DJ

I wanted to let readers know that none of the images in this book have been retouched. The snow is real, the sky is real, the buildings are real, and, most of all, I'm real. It was hard work, and I have the wrinkles to prove it.

DEDICATION

This book is dedicated to all the adopted animals in the world, found or waiting to be found. May we treat them with love and kindness, take care of them when they are sick, play with them when they are well, cuddle up to them, keep them warm and keep them comfortable, and be there when they need us. In other words, give them exactly what they give us.